JOSEPH BEUYS · YVES KLEIN · MARK ROTHKO

BEUYS · KLEIN · ROTHKO

Anthony d'Offay Gallery
1987

Exhibition dates 5 June to 3 July 1987

Anthony d'Offay Gallery
9 and 23 Dering Street, New Bond Street, London W1
Telephone: 01-499 4100

Cover
Jacob's Ladder. Illustration from Volume II of
Robert Fludd's *History of the Macrocosm and Microcosm*
(Oppenheim, Johann Theodore de Bry, 1619)

Printed by Cantz in West Germany
ISBN 0 947564 12 8

We have long felt that the works of Joseph Beuys, Yves Klein and Mark Rothko seen together would be a revelation in terms of the way we look at modern art. Our enthusiasm has been shared by Maria de Corral, Director of Exhibitions for the Fundacion Caja de Pensiones who will be showing an enlarged version of this exhibition in Madrid in September. We should like to express our gratitude for her continual help and support.

Above all we appreciate the assistance of the families of the artists. Our grateful thanks go to Eva, Jessyka and Wenzel Beuys, Rotraut Klein-Moquay and Daniel Moquay, Kate Rothko Prizel, Christopher Rothko and Ilya Prizel.

We have had especial support from Arnold Glimcher and the staff of the Pace Gallery, in particular Marc Glimcher, Peter Boris and Judy Harney. We would also like to thank Heiner Bastian, Regina Bogat, Bonnie Clearwater, Dana Cranmer, Uwe Kraus, Hans Namuth, Diana Roberts, Robert Rosenblum, Harry Shunk, Caroline Tisdall and Maurice Tuchman.

This exhibition would not have been possible, however, without the tireless help and support of Judy Adam, Marie-Louise Laband, Matthew Marks and Anne Seymour.

Anthony d'Offay

TRANSFORMATION AND PROPHECY

Come to the edge, he said
They said: We are afraid
Come to the edge, he said
They came
He pushed them...and they flew
 (Apollinaire)

THAT art is part of man's evolutionary process has been generally disregarded in recent years. Yet throughout the past two centuries art has primarily reflected how we see ourselves in relation to the universe. It has reflected first how we believe we are constructed mentally, physically and spiritually and how we respond to the multiple forces which surround us. Secondly it has discussed the question of the evolution of the human race and whether we have the freedom of will and ability to affect our course by our actions. In the past two decades, a new wave of individual consciousness and a general information explosion has led to an alternative view of modern art not confined to its appearance alone, although art history still does not demonstrate that art has a real function in life as it is lived. We have arranged this exhibition because we believe that these artists — among many others — had a reason for existing which was not merely decorative or reflective.

Both Beuys and Klein saw themselves as prophets or forerunners of a new age, and Klein looked upon Rothko as a precursor. Mark Rothko was not a prophet in the public sense, but his work deals with the language of the future and the normally invisible world, exploring newly discovered areas of consciousness far ahead of his time. Now, nearly twenty years after his death, his paintings are better appreciated, but certainly still not fully. According to Dore Ashton, Rothko felt it a great sadness at the end of his life that his enterprise was not generally understood. He felt alienated by the art of the

Mark Rothko 1964 by Hans Namuth

day, considering many artists simply pattern makers and their work without spiritual content.

"I am not interested in relationships of colour or form or anything else," he told Seldon Rodman. "I am interested only in expressing the basic human emotions . . . The people who weep before my pictures are having the same religious experience I had when I painted them. And if you, as you say, are moved only by their colour relationships, then you miss the point."

Rothko was one of the most articulate and intellectual artists of his generation. Fuelled by the Bible, Shakespeare, Plato, Greek Tragedy, Nietzsche, Kierkegaard, Frazer's *Golden Bough* and a desire for individual and social freedom (which reminds us of his origins in pre-revolutionary Russia), learning from the German Expressionists, Miró, Matisse, Mondrian and Surrealism, he spent long years building foundations, not only for himself, before coming upon the most remarkable of his discoveries. During that time he helped construct the necessary basis and moral ground rules for the first truly international American art, so that, like his own work, proceeding according to Goethe's principle of truth to the inner self rather than the external props of culture, it could deal fearlessly with large issues, large emotions — tragedy, ecstasy, fear, birth and death — the whole 'tragic-religious drama', as Rothko put it, that is life.

He established what we have come to think of as the typical format of his work by 1950, but with hindsight it can be seen that the direction of his vision was set from the beginning. Even the earliest works hint at the unseen world behind the everyday: they have the dematerialisation of form and floating planes that suggest deep inner space, the peculiar ability to indicate space and form as something complex without defining them, the emotionalism and the underlying sense of impending tragedy often found in the later paintings. The pictures done at the end of the thirties and forties are more specifically about the invisible world. They seem to contain, rather as do the drawings of Joseph Beuys, a sense of looking into the universe, of exploring universal patterns of ideas, the invisible patterns of evolution. We are shown the precision of its structures, the spread of time, the part played by emotion and by ethics, the artist's direct link with the primordial life and primordial light Nietzsche wrote about. These important

pictures are by no means to be regarded simply as biomorphic imagery; they are to do with creation and evolution and the history of man, with events which are built into all of us at the deepest levels biologically and psychologically.

Although he cared for human beings most of all, for human emotions and the survival of humanity, Rothko ceased to work figuratively because he felt he was mutilating the thing he loved. Transcending the literal human image did not mean he cared any the less. He insisted "upon the equal existence of the world engendered in the mind and the world engendered by God outside of it," saying "I love both the object and the dream far too much to have them effervesced into the insubstantiality of memory and hallucination."

He regarded his abstract paintings as presences, similar to human presences, charged with energy and emotion, to be treated with love and reciprocity and protected from the wrong environment and negative responses. He already recognized this in 1947 when he said "A picture lives by companionship, expanding and quickening in the eyes of the sensitive observer. It dies by the same token. It is therefore a risky and unfeeling act to send it out into the world."

The idea of the human being as both transmitter and receiver of energetic forces on spiritual, physical and emotional levels is an image we are more accustomed to seeing in the work of Joseph Beuys. Yet that is exactly what Rothko has understood in the abstract paintings from the last twenty years of his life. Furthermore, they make complete sense in that respect when seen to follow directly on from the so-called 'Surrealist' works, for they make it actively clear that we are very much part of all the energetic forces outside ourselves in a very real and physical way. Beuys and Klein make the point again and again in their work, and it is one of the reasons for the element of dematerialisation it contains, which is always balanced by the idea of reality. In confronting a Rothko, the viewer becomes acutely sensitized and conscious of his own receptivity on many levels. He also seems to dematerialize in response to the nature of the painting in front of him, identifying with it almost to the extent of becoming it. But while the receptivity is part of it, the viewer also loses the intrusive sense of self as he feels the emotion the painting contains.

What Rothko is transmitting to his paintings, which become energised as transmitters

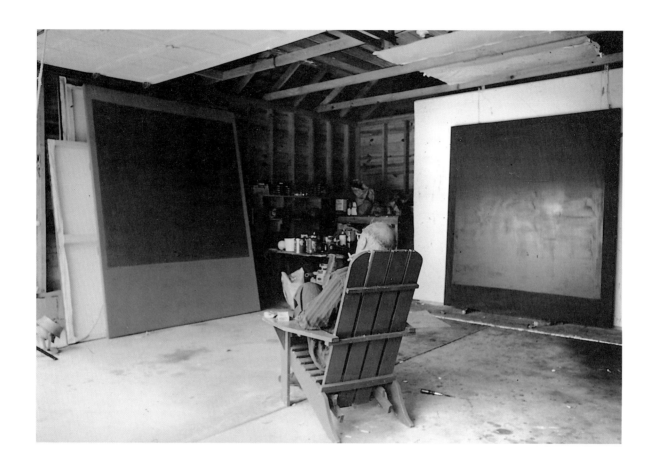

Mark Rothko 1964 by Hans Namuth

in themselves (like all works of art), are his spiritual and emotional responses to a particular idea, and he often spoke of the single tragic idea. The process may start in the mind but then descends to a deeper spiritual level: "Ideas and plans that existed in the mind at the start were simply the doorway through which one left the world in which they occur." Thus it becomes possible for Rothko to say "For art to me is an anecdote of the spirit, and the only means of making concrete the purpose of its varied quickness and stillness."

The concreteness of this spiritually conceived idea can apparently be transmitted by colour and the substance of colour, just as it can by music, and Rothko was a notable music lover. It is not known to what extent, if any, Rothko thought scientifically about colour, whether he was aware of Goethe's theories or whether he simply worked intuitively. Colour can certainly have particular physical and mental and spiritual effect; it can heal, stimulate and depress, it can be perceived by touch by the blind. Colours all vibrate at different rates with red the slowest. Rothko was especially fascinated by red. He spent many hours in front of Matisse's *Red Studio* in the Museum of Modern Art in New York. Diane Waldman cites its powerful and basic associations: its identification with the elements and ritual — with fire and with blood — and thus with life, death and the spirit. Colour in Rothko's paintings also often vibrates through the way it is applied, and as a translucent substance infused with light it is often overlaid on top of other colours, so that the one lives in the shadow of the other. Colour is, however, not just colour and Rothko's paintings have a highly important and energetic material existence, both formally and substantially.

At present, there is no way of telling what it is that causes the emotions or the elemental forces tapped by him, the painter, to be transmitted to the viewer. Rothko may be seen as acting like a shaman filtering information from the invisible world, but he was adamantly anti-mystic, stating again and again his concern with real life, real emotions and the real material existence of his paintings. However, the parallels with Zen Buddhism of the kind we shall talk about in relation to Klein perhaps cannot have escaped him. Like Beuys and Klein, Rothko came up with something which, though it seemed beyond normal consciousness at the time, finds an increasingly immediate response today, a means of deep instant and active communication without words. Rothko is the kind of prophet and seer who is not always recognised in his lifetime. And he is the kind whose door you have to

knock on in order to find him, but once the threshold is crossed — and it is easier every time — then the world seems to begin again.

Rothko cared intensely about society; around the time of his suicide in 1970 he worried greatly whether the world would last another decade. In his last paintings he expressed his emotion through light and darkness in confrontation, without the cloak of the spectrum of colour that is the property of light through its interactions with darkness. The two opposing poles of life face each other across the horizon. The delicate balance between the urges of life and death is a pivotal force and a matter for constant meditation in many of Rothko's paintings, but it seems that at the last he doubted that mankind had indeed the ability to transform itself despite the living proof in his own work that it could.

Although the approaches of Beuys and Klein were entirely independent of one another, many of the ideas which motivated them came from similar sources — European and Eastern religious, philosophical, scientific and occult writings, myth and shamanism. Beuys's work, rising out of the ashes of postwar Germany, is characterized by his astonishing range of knowledge and boundless curiosity across the spectrum of the sciences and humanities. The core of his philosophy, however, derives from Goethe's world view and insistence that the self is the only proper standard of truth, and also from the subsequent and multifarious writings of Rudolf Steiner. Beuys's ideas about the construction of the trichotomy of body, soul and spirit, about reincarnation, about evolution, the importance of the Crucifixion as an historical event, his theories about birth, death and rebirth, about intuition as the highest form of reason, power of the will and the potential of limitless knowledge — all have obvious connections with Rudolf Steiner.

Klein's brief, high-pressure career (he died of a heart attack aged only 34 in 1962) allowed for a less scholarly and detailed approach in his exploration of man's place in the evolution of the universe. However, he took Rosicrucianism, Zen Buddhism, Existentialism, evolution and alchemy in his stride and affected the course of European art profoundly as he returned again and again to the book which had first inspired him as a destiny-conscious teenager: Max Heindel's *Cosmogonie des Rose-Croix,* written in the early years of the century, contemporaneous with Steiner's *Occult Science.*

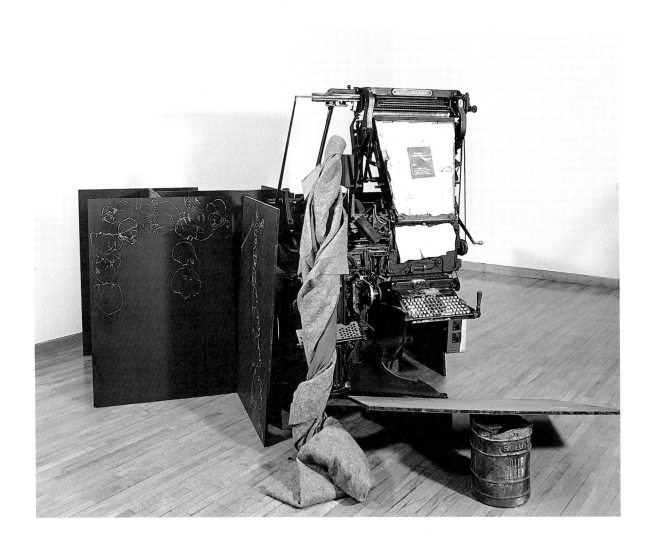

Joseph Beuys *Terremotto* 1981

Steiner and Heindel had, of course, the same sources (Steiner also wrote elsewhere about Rosicrucianism) and both subscribed to the ancient prophecy that apparently at some unspecified point in the third millenium, man would, by his own efforts and the strength of his powers of thought, be able to transform himself, escape the material age and enter a new evolutionary phase of vastly greater spirituality and sensibility. Both sought to educate their fellow men in order that this state might be brought about.

Each of Joseph Beuys's major works is a synthesis of his entire philosophy. Thus it is not unreasonable to define his revolutionary approach on the basis of a single work. We have chosen *Terremoto* (Earthquake) 1981, based on the machine for casting type, which Beuys made, in the practical instance to aid the ailing Socialist newspaper, *Lotta Continua* (The Struggle Continues), but also for the city of Naples with which he felt a special affinity, and which in 1980 had suffered a devastating earthquake. Beuys's commitment to social sculpture and the establishment of a new social order sent him to the aid of *Lotta Continua,* just as it had caused him to go as artist, healer and shaman to Naples in the aftermath of the earthquake. There, on Good Friday, he made an action entitled *Terremoto in Palazzo,* and also wrote a stirring article entitled *The concept of the Palazzo in the human head, questions and demands* for the Naples newspaper *Il Mattino.* In it he compared the tremors which devastated the towns and villages of Naples and the Mezzogiorno with the crumbling of the edifices of both Western and Eastern state capitalism and offered the people of the area a healing solution or rebirth based on self-determination and social democracy.

Beuys had a special fondness for Naples. He knew much about its history and the reasons for its decline. He often said he felt it had been his home in a past life and for many years he visited the city almost annually — usually at Christmas or Easter. Most of the work he made there has very specific connections with the place. He loved its energy and the energy of its people. It is no accident that Beuys's last major work, *Palazzo Regale* (Palace of the King), was created there, for just as in a sense he felt it was his place of birth, so also he felt it marked his death and rebirth in another condition.

"Each and every man has the most precious building in the world in his head, feelings and free will," Beuys wrote in *The concept of the Palazzo in the human head;* and one of the most

important things about *Palazzo Regale* is that, despite appearances to the contrary, it is less about the body than about the head and spirit of the artist. His bodily attributes and possessions are displayed in glass cases, but his mind and spirit, freed from the ego, fill the room. (The ladders in Beuys's smaller last works suggest the same direction — the celestial ladder of consciousness.)

The parallel between the palace and the head, which goes back to Beuys's childhood idea of "Prince of the Roof" when using the power of the mind, is also demonstrated by a drawing entitled *Terremoto in Palazzo*. It shows the relationship of the head to the movement of the planets, and is comparable to many earlier drawings depicting the receptivity of the shaman to such things — higher forces or invisible energies — sometimes through ecstasy or by means of a third eye or antenna. In *Terremoto*, the blackboards propped around the machine are covered with drawings of heads. As well as the power of words and speech, they seem to suggest the aspect of spirituality and ecstasy, though they also perhaps depict mankind struggling through the darkness, strongly affected by shifting balance and continual upheavals of society. The machine which forms the central core of the sculpture, through the words it produces, appeals directly to the head. It could indeed be seen as a head in itself. However, it is also a sort of alchemical crucible. For the machine is used for casting lead type, that is to say, in following the alchemical metaphor, it is for transforming lead (or base consciousness) into gold (or enlightenment).

The concept of energy is primary in Beuys's work, whether seated in the powers of electricity, magnetism, thought, conversation, metamorphosis, earthquake, biological or spiritual changes in birth, death and evolution, or in matter generally. Beuys was, however, less interested in the energies of different substances, as in how they could be used in "constellations" of ideas. His theory of sculpture begun in the late forties demonstrates his conception of the passage of organic matter through sculptural movement to ordered form, a passage from warm to cold. This developed in the sixties to include social sculpture, involving the creative talent of every individual, paving the way for a regeneration of thought throughout the world and for a society of the future based on individual creativity.

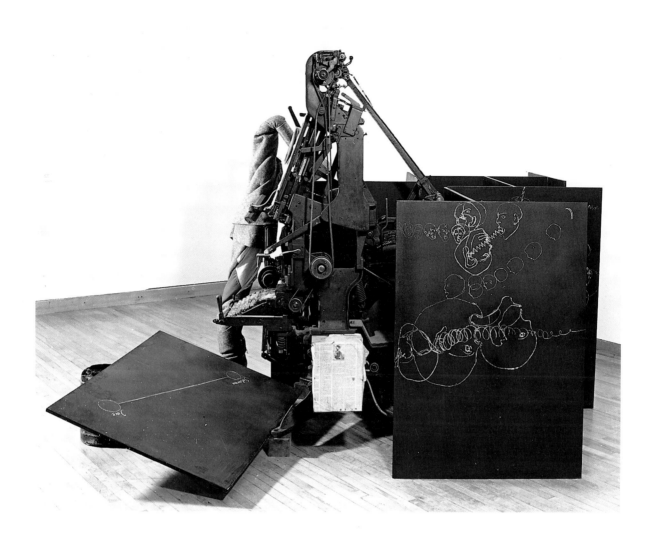

Joseph Beuys *Terremotto* 1981

When asked about his identification with the earthquake, Beuys replied "In that work I became a sort of 'energy-aerial', the energy being the fire that lives in the bowels of the earth. I experienced a sense of vitality and not just the elements of catastrophe. In a broader sense, it was the creativity that is present in nature." Later he said, "There has always been the concept of heat and thermal variation in my works. The values are present not only in the earth, but also in mankind itself. Years ago when I spoke about thermal sculpture, I wasn't referring to anything static, but rather to a type of sculpture that would have as its source the element of the explosive potentiality of energy, which becomes a metaphor for thought." (A reminder that Beuys considered intuition the highest form of reason.)

Many of Beuys's sculptures involve machines; some are concerned with the transmission of energies beneath the earth's surface, others may be machines for the realisation of economic theories. Some are scientific, some imaginary, but all potentially "work." They have included transmitters, transformers, batteries, magnets, torches, telephones and the famous Honey Pump. What is also common to all these machines for creativity is that they involve a change of condition, a surge of energy, a movement from warm to cold. *Terremoto* is a metaphor for a constellation of ideas which "works," but it also postulates flux, the continuous change which affects everything in the world and makes it a transitional stage in a larger process.

Beuys adopted the role of shaman, the wise man of primitive tribes, in a twentieth century context and wore a "shaman's" hat as a kind of visible badge of office. The shaman's traditional role as wounded healer is strongly implied in Beuys's work to do with the earthquake. Not only did he present a solution to the financial problems of *Lotta Continua*, he came to the aid of the victims of the earthquake and offered important curative solutions to the wider problems aggravated and exposed by it. He proposed the restoration of spiritual balance to the situation by the metaphorical home-opathic means of treating like with like, producing machines which mimic the upheaval within the earth.

Of *Terremoto in Palazzo* he said "The work I did was meant to exemplify the central problem of *balance*. Everyone knows that balance has to be searched for, although in reality

it doesn't exist. Not even in today's society can you find any economic balance, whereas ecological balance still exists in nature. It is important therefore to take the latter form as a model". The action *Terremoto in Palazzo* included furniture balanced on glass bottles, in *Terremoto* the blackboards are balanced around the machine for casting type, but in both cases it is the larger upheaval, involving the precarious balance of society which the artist undertakes to bring back into harmony, to extricate from chaos, to return to a state of spiritual balance.

Beuys identified the machine for casting type as a means of making sculpture, literally and metaphorically, but most importantly the art that results does not belong simply in the world of aesthetics. By a new stretching of the frontiers of art he involves the people who are fighting for survival in modern life, creating a truly social sculpture. Like many of Beuys's works, *Terremoto* suggests a rebirth, in this case one which is offered to the citizens of Naples and the Mezzogiorno. As he pointed out, "Man, you possess the force of your own self-determination". His fundamental belief expressed also in many lectures and drawings was that the capital of the people lies in the creativity of each of its individuals.

Yves Klein was deeply aware of his own destiny, both in the vocational and in the finite sense, and interpreted the events of his life accordingly. He saw himself as the messenger of great tidings, a new man with a new art for a new world. He believed that a new age was on the way, a technological Eden where history would cease and art would be a language of pure emotion communicated directly between perceptive individuals. He envisaged transference of thought and dreams, levitation and flight and thus direct communication with the spirit world. And he also recognized his embodiment as the tragic idea of man born to die. The warfare is accomplished but completion of the vision requires the participation of all of us. Klein hovers at the crossroads, offering us glimpses of the new world which is to be discovered if we are prepared to enter the world of the spirit. In the blue monochrome paintings he invites us to enter the Void, the space of absolute spiritual reality, in the Anthropometries he dematerializes the body so that we may learn to fly. Working with gold he hints at alchemy, and with the elements, as in the Cosmogonies and Fire Paintings, at his ability to handle the dangerous forces of creation as well as the benign.

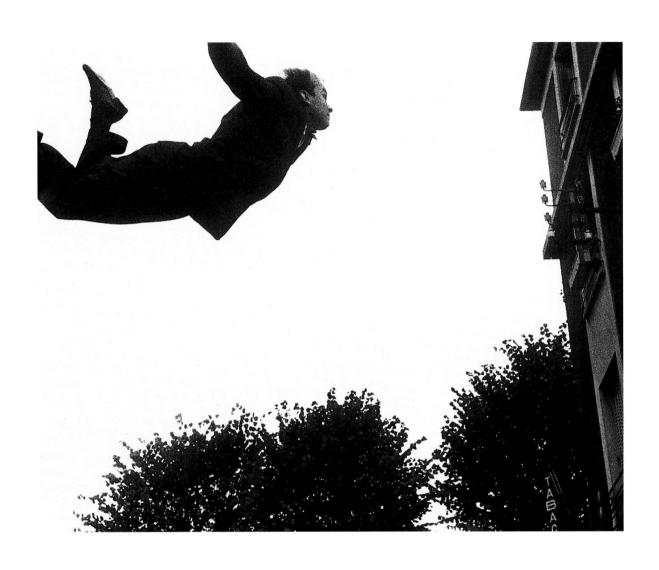

Yves Klein 1960

The Christian parallels are obvious. But as in Rosicrucianism Christianity is fused with the philosophy of the East (Christian Rosenkrantz is credited with this achievement in the fifteenth century). In this century, the theme of rejoining East and West has been constantly recurrent at all levels, through wars, science, art and the movement of peoples. Rothko came from Russia as a child and his emotions remained Russian while his intellect ranged across the globe. As a child Beuys saw himself embodied in Genghis Khan and later in the shamans of Siberia, he became the mystical, fertile hare crossing the great plains of Eurasia from East to West, and was well acquainted with the joining of Eastern and Western philosophies in the writings of Rudolf Steiner.

Almost at the same moment as Yves Klein discovered Heindel's book, the astronomer Fred Hoyle wrote that everything would change with the first photograph of the earth from space; however, it looks as if the power of the thought preceded the event. Klein was not alone in being gripped by the idea of a new art for a new world, as is demonstrated by the explosion of new movements everywhere in the fifties and sixties, including those Klein himself was close to, the Zero group in Düsseldorf and the Nouveaux Réalistes in Paris. Nevertheless the global, universal and cosmic view it would be possible to give to art unquestionably dawned on him as a result of reading Heindel. And inevitably such a vision could not but throw into relief the parochial qualities of l'Art Informel which dominated the French scene after the war.

The *Cosmogonie des Rose-Croix* was obviously crucial to Klein, but it should be remembered that the information it contained could also be found elsewhere and Klein certainly explored and expanded many of its ideas outside its framework. One such area in particular is the firm countering of the mystical aspects in Klein's work with reality and the strong connections in that context which his work suggests with Zen Buddhism and the culture of Japan, which Klein experienced at first hand when studying judo there on a professional level.

One characteristic of the impact of Zen on art in the twentieth century has been its growing insidiousness. Its ethics seem to become part of people's moral philosophy and awareness even without the benefit of such opportunities as Klein's to study the subject. With Klein, the relationship is especially interesting for the way it counters the more

hysterical side of the image he chose to present. For on the one hand there is an important level on which Klein's work has to be seen as drama, while on another it involves solitude and meditation. On one side we have the monomania of 'Yves le Monochrome', on the other an ego-less merging with the Void. And of course there is also the god-like aspect of being able to change between the two.

Zen's firm insistence on the world of facts has had an enthusiastic response from many postwar artists and not least these three. And it seems likely that Klein's use of universal, real substances and forces, pure pigment, gold (earth), architecture of the air, flight (air), flame torches and flares (fire), rain on pigment (water) is not a purely alchemical reference or a reference to Heindel's book, but may also relate to the Zen idea of experiencing reality in its actual concreteness. His use of real bodies in the Anthropometries has a similar basis, though at the same time he brings in his god-like capacity to counter it with the simile of living brushes. He always liked to give things an official seal, down to paying the post office to frank his own blue stamps. For the architecture of the air he experimented with real scientific and architectural possibilities (found to be impossibilities), and when working with fire he chose to face real dangers, working huge gas torches with a fireman standing by. The transformation which takes place in front of a blue monochrome is to do with the pulsating energy of its reality. It is both a stepping stone towards the void of absolute reality and that reality itself. The experience of the latter comes at the point of enlightenment, which in Zen is synonymous with freedom. It is the moment of absence of selfhood in Zen when subject and object merge in absolute emptiness. In Zen the attainment of absolute reality or emptiness (the Void) has to be made in the midst of all the facts of the universe. It must not be abstracted from reality by means of thought. Such reasoning may well have led Klein not only to use real materials but also to take real action and real life into the world of art.

The physical presence and participation of the artist and observer are extremely important in Klein's work. The role of the physical body in his philosophy probably goes back to his study of judo (his first experience of spiritual space), which Klein practiced for much of his life and was no doubt confirmed in the lessons and exercises sent from Oceanside, California, by the Rosicrucian Society providing guidelines for appropriate

living, including eating, breathing, meditation, creative visualisation and sexual abstinence, in pursuit of the creation of the new spiritually-bodied man for the new age. Parts of Klein's approach have parallels in the anti-materialism of the Japanese tea ceremony, others in Zen and the Art of Swordsmanship where, incidentally, the blue sky is used metaphorically for bringing the mind to freedom and inner harmony.

Klein worked with earth, air, fire and water on one level very much in the sense that he was an initiate who could handle them. However, we know that the strain of controlling the fire images may well have contributed to his death, and we know that he could not physically inhabit the air in his present state of evolution without having a photographer help him dematerialise his act. That his human frailty was explicit is important not least because it presented a tragic situation, although there was always the implication that this could in theory be remedied by energy and the will to succeed with change.

Although linking East and West in important ways, Klein was not Japanese. The other side of his image showed he was a realist in a highly Western sense. Perhaps what he was proposing was too new and too sudden to be taken straight and in any case the humorous side was not to be denied to life. Klein's friend, Claude Pascal, has described how Klein always laughed but was always dead serious. (Tagore: The burden grows lighter if I laugh at myself.) Klein created, from a sythesis of his art and life, an extraordinary, poetic, multi-layered, four dimensional totality. He was one of the first artists to use the modern publicity machine and media as a logical part of his art. The public images Klein produced for himself were absolutely deliberate. He appeared as engaged in a knightly crusade, searching for the Holy Grail (also a Rosicrucian reference), becoming a Knight of the Order of St. Sebastian. He figured as alchemist, scientist, conjuror, ringmaster, Mandrake the Magician and Tintin. He aimed to catch the interest of Paris intellectualism and the materialist world of fashion, newspapers, theatres and cafés. When he presented *Le Vide* (The Void), an empty room which he had painted white and filled with creative visualisations, it was a society event with cocktails from La Coupole which made the drinkers urinate blue for week. "Great beauty," he wrote, "is only a reality when it contains, intelligently mixed into it, 'genuine bad taste', 'irritating and intentional artificiality,' with just a touch of dishonesty."

Yves Klein 1961

Klein seemed determined to reach as many people as possible in the short time available. The effort was superhuman and hastened his death. The parallel with his brief-burning fire machines is obvious, but he can also be compared to the blue cocktails, for he got inside society without its being able to do anything about it. Zen and Strontium Ninety have done the same thing. Klein was undoubtedly one of the great figures in the movement which has swept twentieth century art from beginning to end: namely, the dematerialisation of the body and the materialisation of the idea. In this enterprise, lightness of touch is essential for only thus can art achieve that magic life of its own, that sense of getting off the ground.

Writing in 1973, Robert Rosenblum began the penultimate chapter of his important *Modern Painting and the Northern Romantic Tradition, Friedrich to Rothko:* "The Paris-based ideal of art for art's sake so fully dominated the mid-twentieth century view of modern painting that it has taken almost half a century to realise that the impulses behind the creation of much abstract [and not only abstract] art were anything but aesthetic in character." His book describes many of the thought structures which lie behind the work of the three artists in this exhibition. Although he did not include either Beuys or Klein under the heading of his argument, Rosenblum suggested an alternative motivation for much art of the past two centuries. That he wrote his book at this time is an indication of the growing pressure of thought in this direction. However, that he did not include Beuys and Klein, or Long or Kiefer or Gilbert and George, suggests that their manifest connections to the ideas he described were still then being obscured by their medium and that he was not fully conscious of the implications of the paradigm shift which motivated him.

Just as there are now no secrets of knowledge, we are perhaps, as Beuys, Klein and Rothko indicate, beginning to transcend history and develop a new view of time based on a sense of continuous present, where individuals take responsibility for themselves and cease to struggle with the past. Steiner and Heindel were representative of a trend in the nineteenth century ranging from Blake to Van Gogh, in which free thinking ideas about the spiritual and social role of man began to surge forward. Beuys, Klein and Rothko seem to fit in with similar but more recent waves coming from the same direction.

There appears to be a growing network of freethinking individuals in all walks of life, some aware of their connection, others unaware, who seek alternative solutions to problems when the solutions on offer fail to work, who do not wait for the world to change, knowing that if we are to change society we have to change ourselves because we are the future. The shift overtaking us, many believe, is not a new political, religious or philosophical system. It is a new mind — a startling world view which includes in its scope the most recent breakthroughs in science and insights from the earliest recorded thought. Are we in the grip of what historians of science call a paradigm shift or could this be part of the evolutionary trend Beuys and Klein believed in?

The idea of such a non-collective collective enterprise is perhaps the only thing that makes sense of an organism like humanity, made up of individuals who are all connected together and all completely separate. However, it is easiest to be a prisoner, to pretend, to anaesthetize oneself against taking the responsibility of individual freedom. Rudolf Steiner wrote "When a man renders his life waste and void by losing his connection to the supersensible, he not only destroys within himself something of which the death may ultimately lead him to despair; but by his own weakness he becomes a hindrance to the evolution of the entire world in which he lives". Many artists have said that when life becomes fully conscious art as we know it will vanish. Although he made a drawing of himself as a primitive creature, a digging dwarf, to demonstrate his position in that evolutionary context, Beuys for one believed that what was to come would be greater by far than anything the world has ever known.

<div align="right">Anne Seymour</div>

PLATES

JOSEPH BEUYS

1921-1986

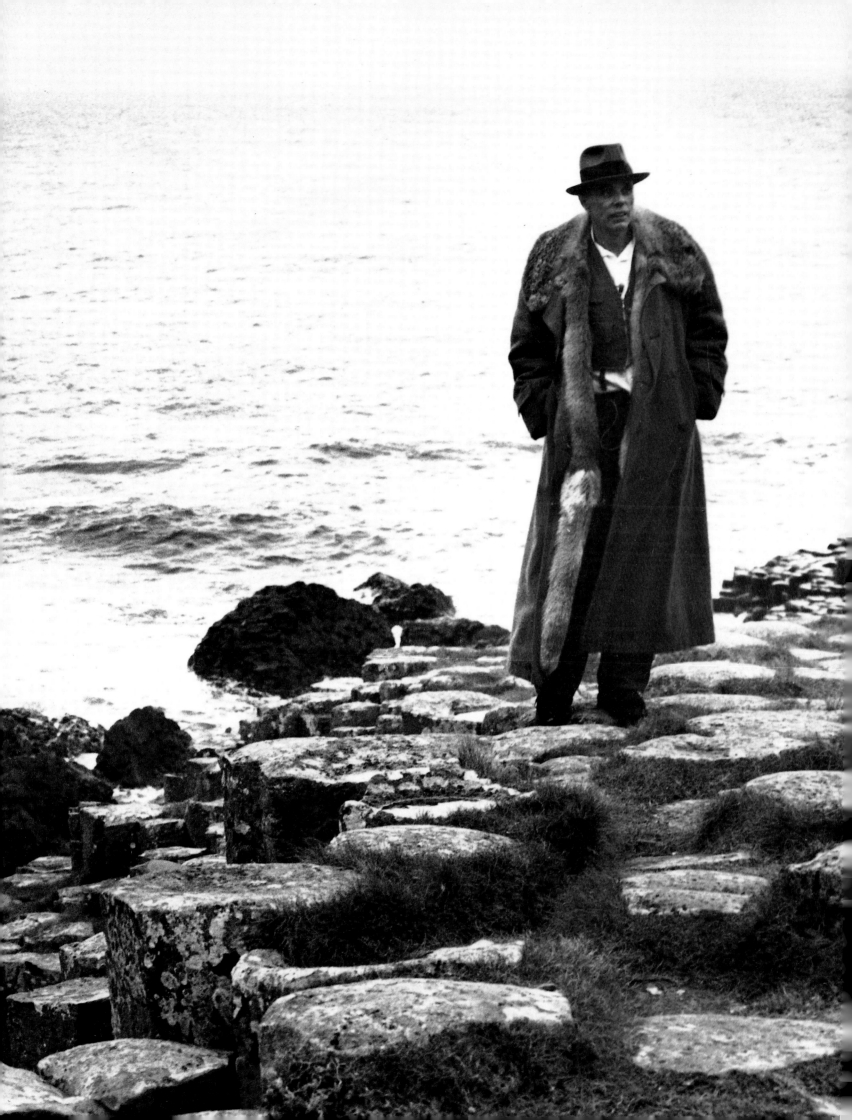

1

BRAUNKREUZ HOUSE 1962-64
Vitrine, 81 x 86½ x 19½ in

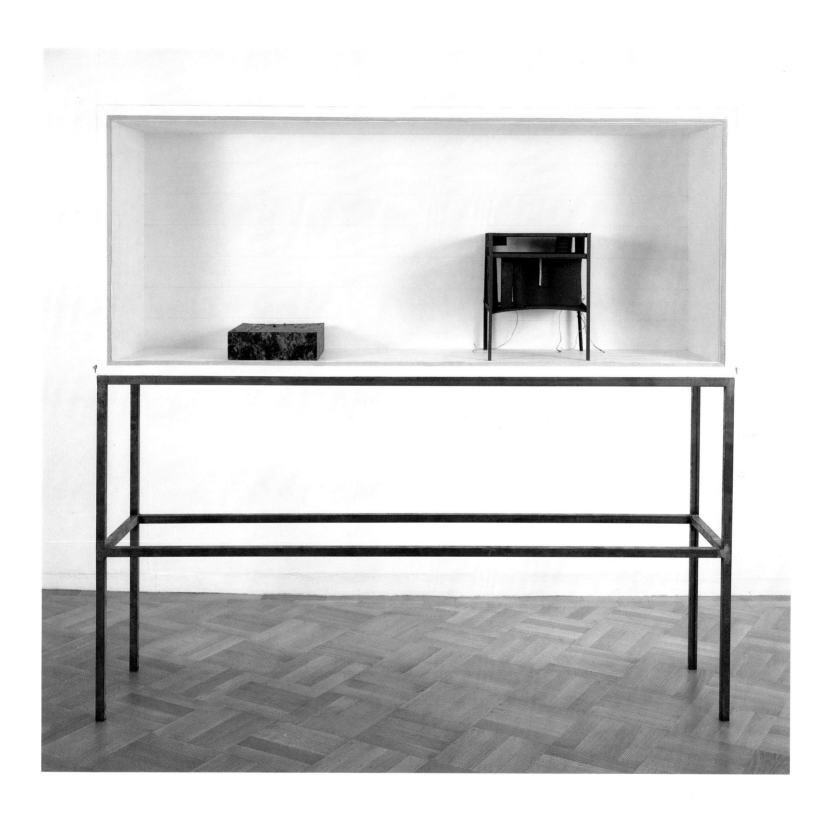

2

SLEDGE WITH FILTER 1964-69

Vitrine, 81 x 86½ x 19½ in

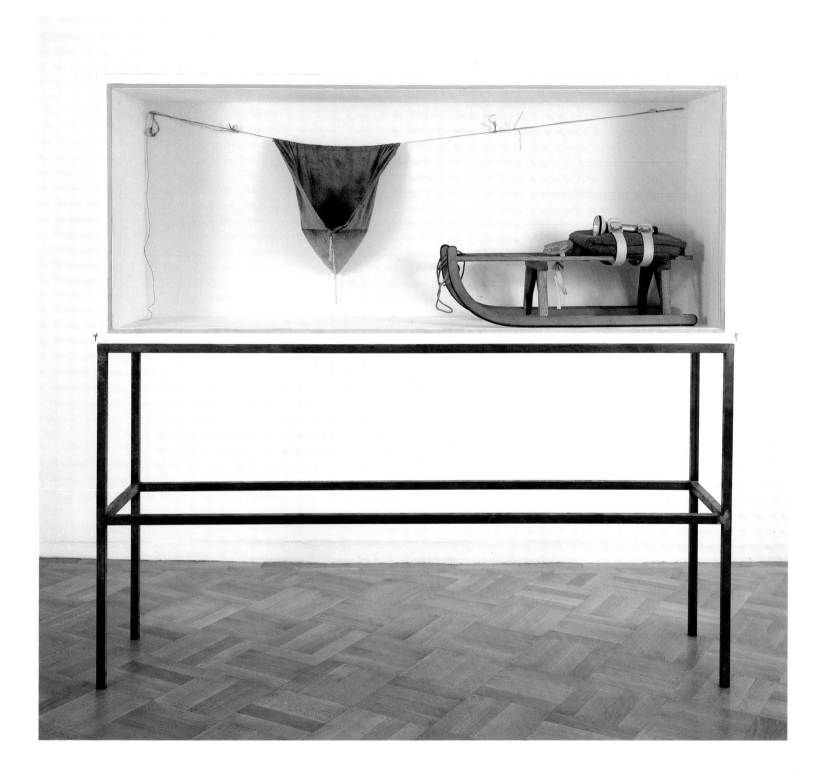

3

LOCH AWE 1963-70

Vitrine, 81 x 86½ x 19½ in

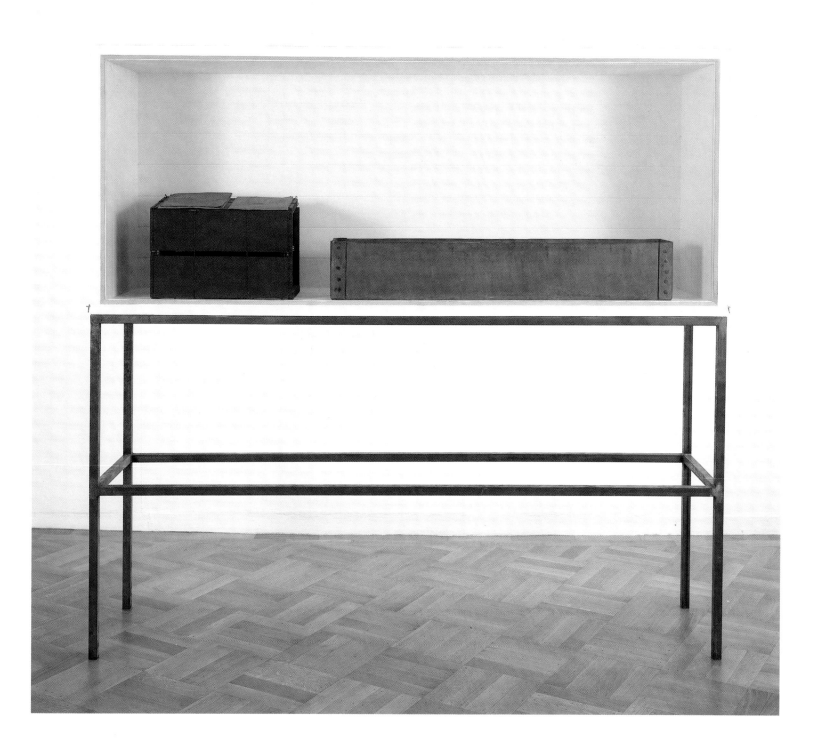

4

DOUBLE OBJECTS 1974-79
Vitrine, 81 x 86½ x 19½ in

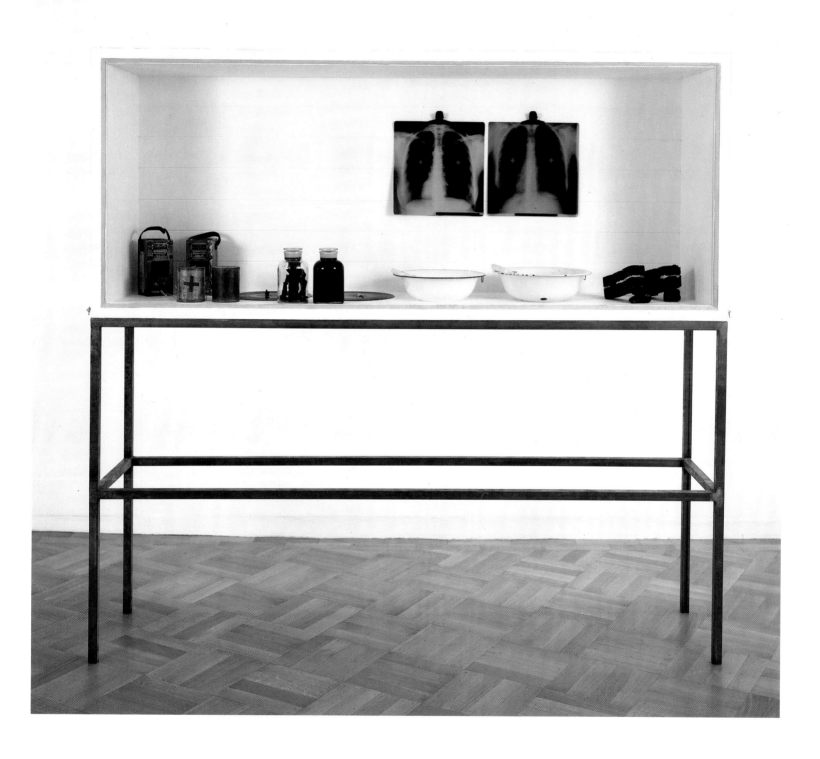

5

BRAUNKREUZ 1962

Oil (braunkreuz), 2 parts: each 11¾ x 8¼ in

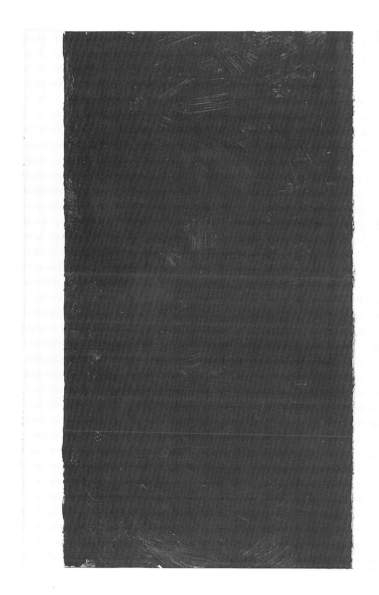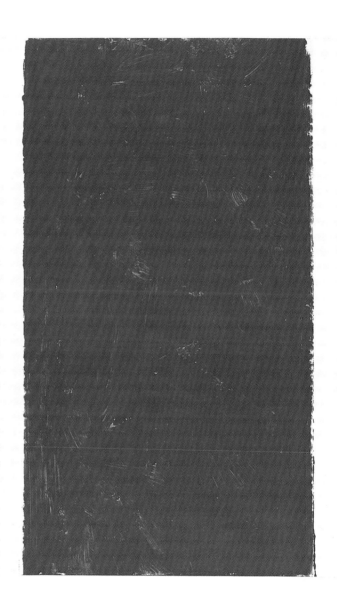

6

CONDENSED FIELD IN BRAUNKREUZ 1963

Pencil and oil (braunkreuz), 14¾ x 11 in

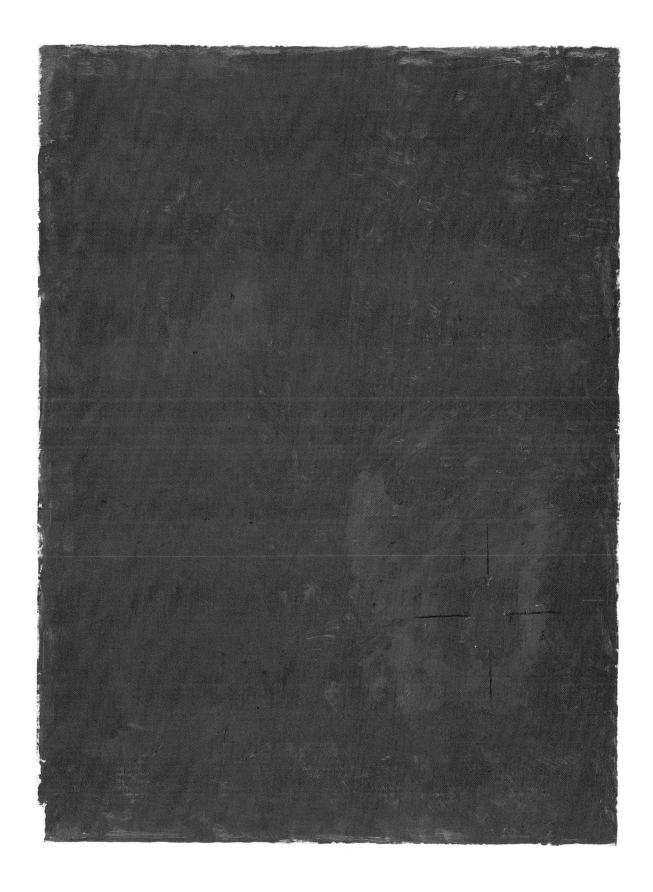

8

BRAUNKREUZ 1964

Oil (braunkreuz) and fat on card, Diameter: 8½ in

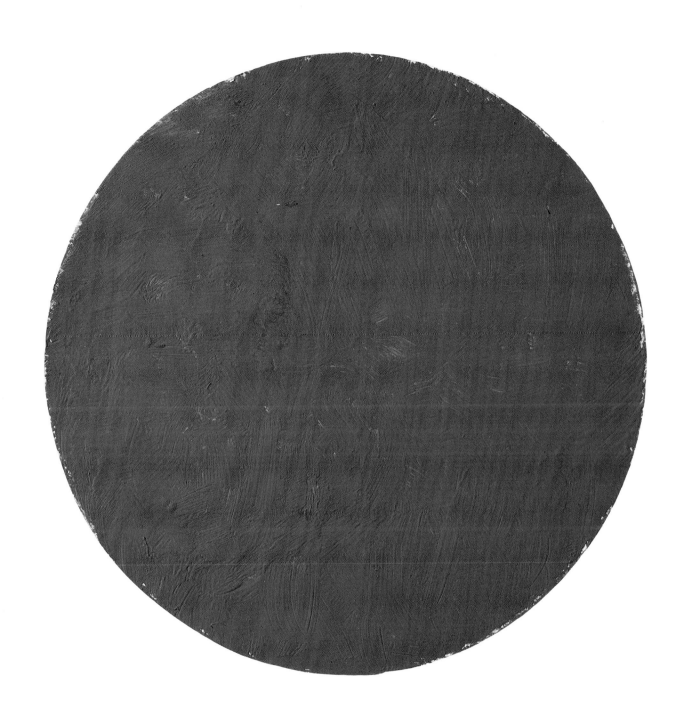

9

FOR BROWN ENVIRONMENT 1964

Oil (braunkreuz), 2 parts: 31½ x 19½ and 31½ x 13 in

10

FOR BROWN ENVIRONMENT 1964

Oil (braunkreuz), 2 parts: 23½ x 11¾ and 31½ x 13 in

YVES KLEIN

1928-1962

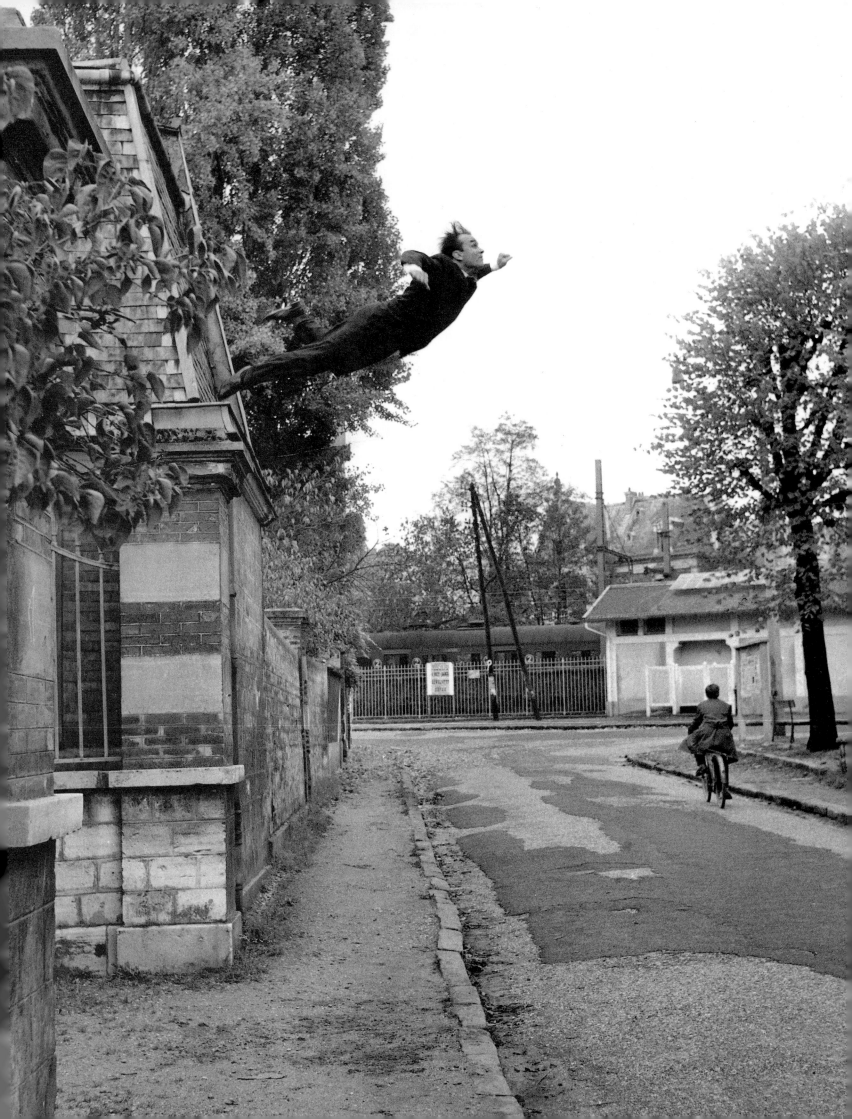

1 2

ANTHROPOLOGIE DE L'EPOQUE BLEUE 1960

Blue pigment and synthetic resin on paper mounted on canvas

85¾ x 52 in

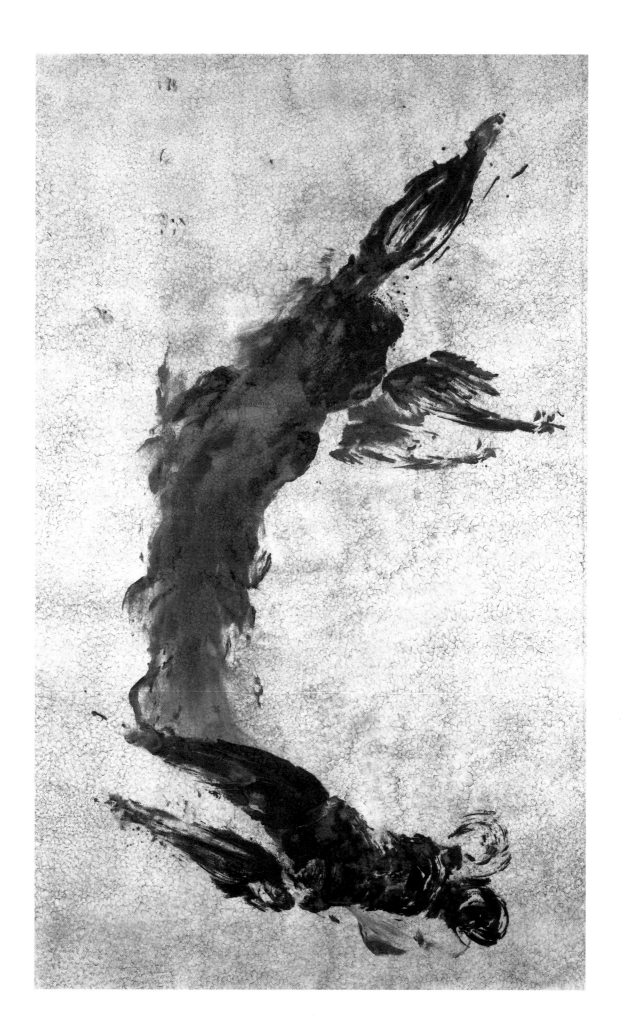

1 3

CHEVEUX 1961

Blue pigment and synthetic resin on paper mounted on canvas

41½ x 29½ in

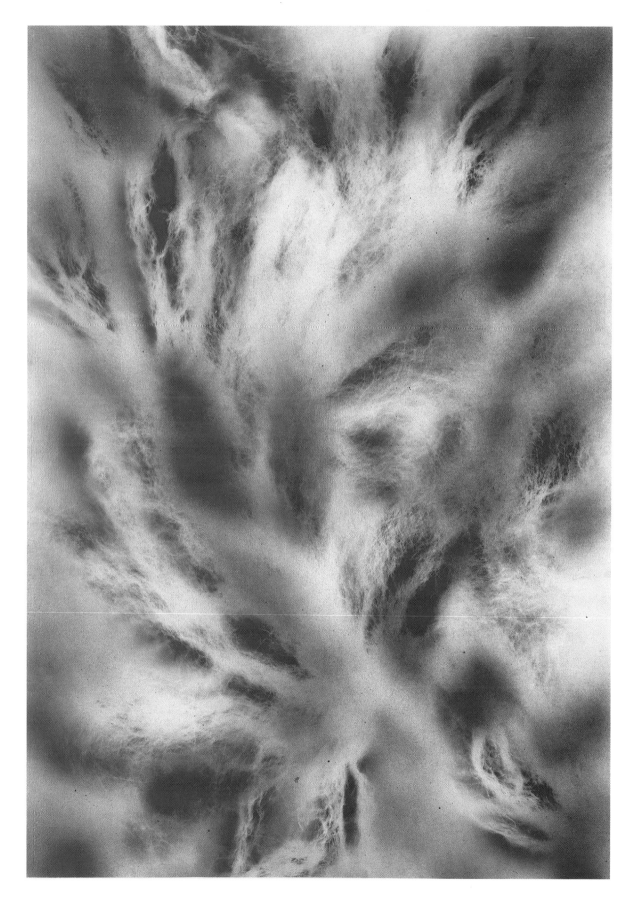

14

ARCHITECTURE DE L'AIR 1961

Blue pigment and synthetic resin on paper mounted on canvas

103 x 78¾ in

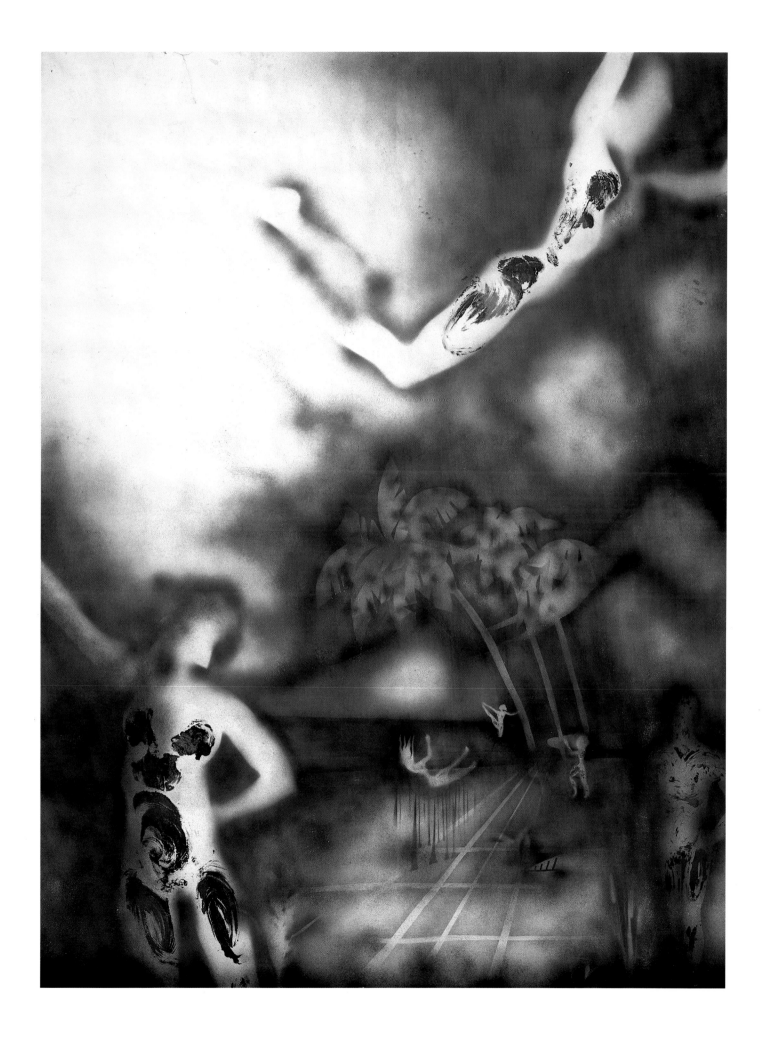

1 5

ANTHROPOMETRIE 101 1961

Blue pigment and synthetic resin, fire, gold and cosmogony

on paper mounted on canvas, 165½ x 78¾ in

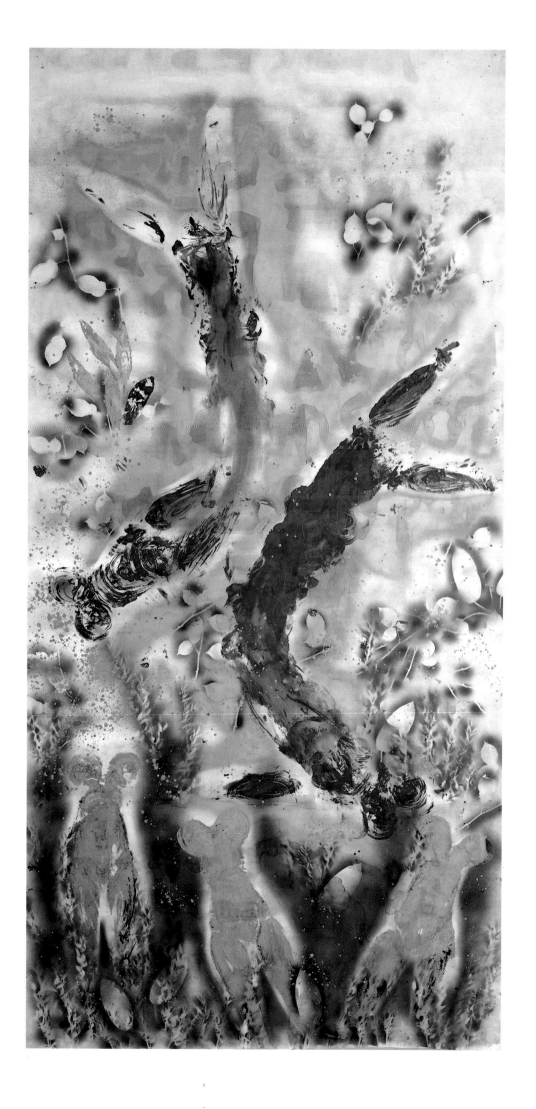

16

FIRE PAINTING 1961

Fire on paper mounted on wood, 25½ x 19¾ in

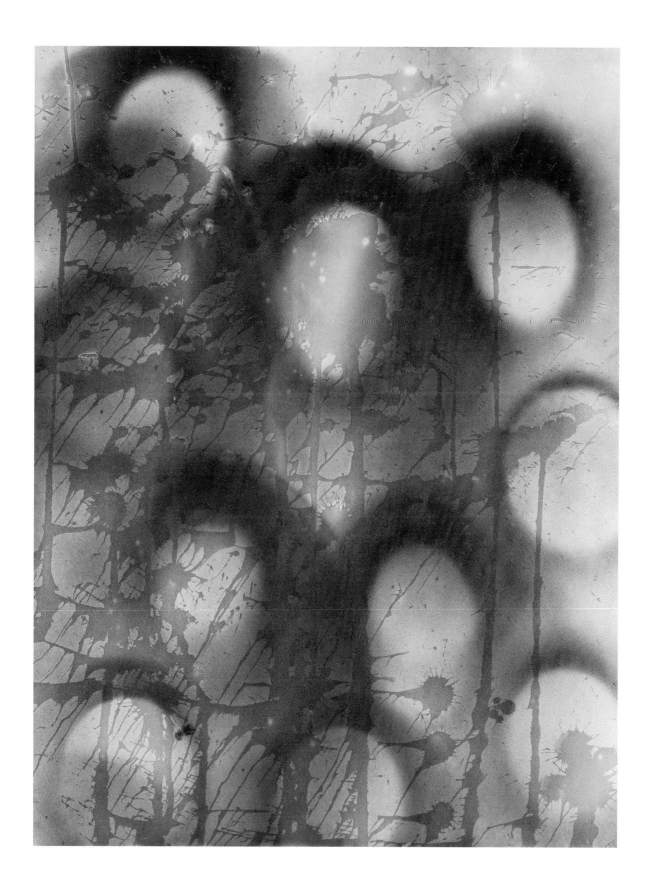

17

FIRE PAINTING 1961

Fire on paper mounted on wood, 31½ x 43½ in

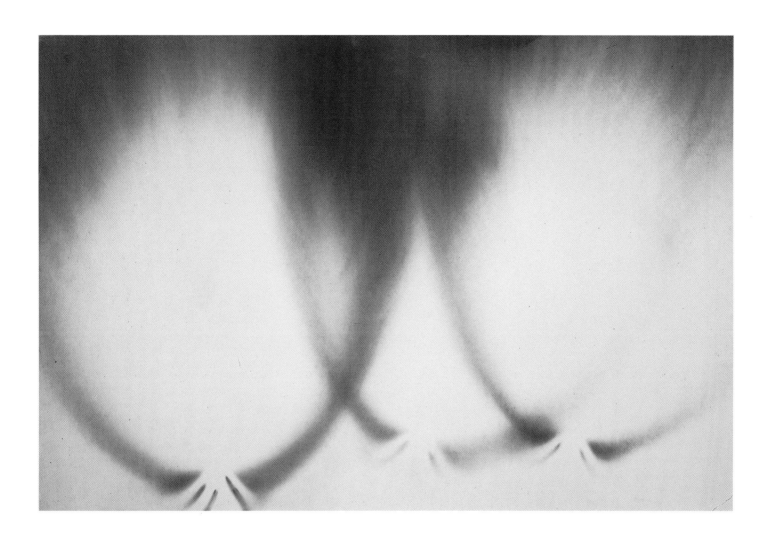

1 8

FIRE PAINTING 1961

Fire on paper mounted on wood, 28½ x 40½ in

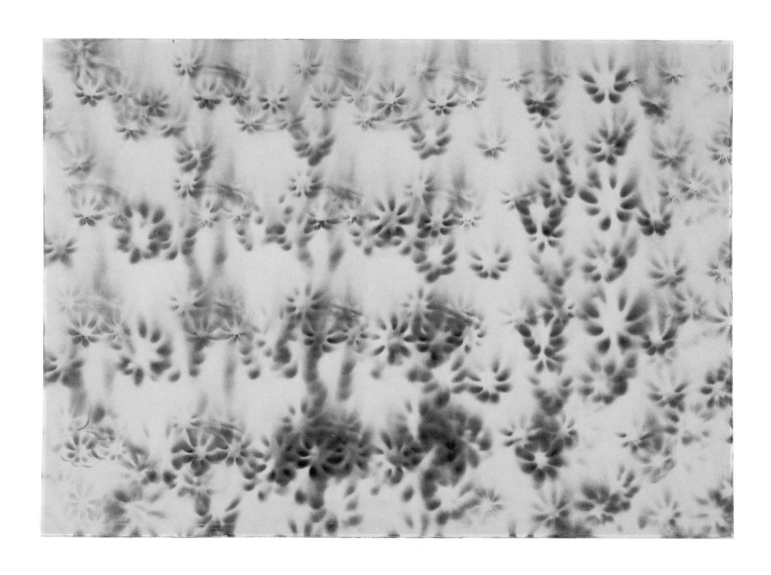

19

FIRE-COLOUR PAINTING 1962
Fire and pigment on paper mounted on wood, 43½ x 35 in

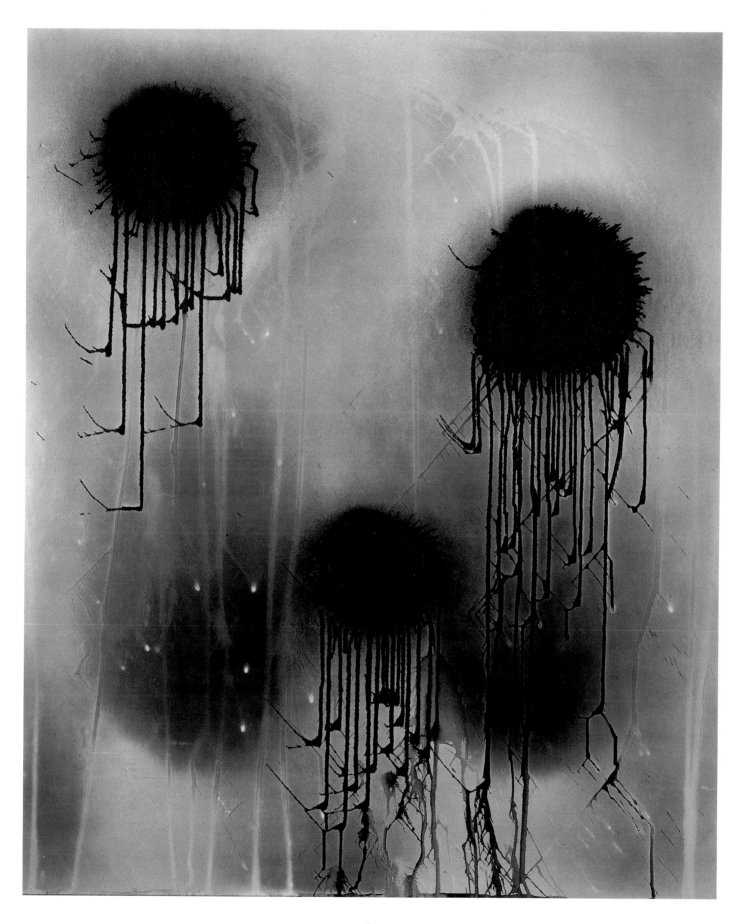

MARK ROTHKO

1903-1970

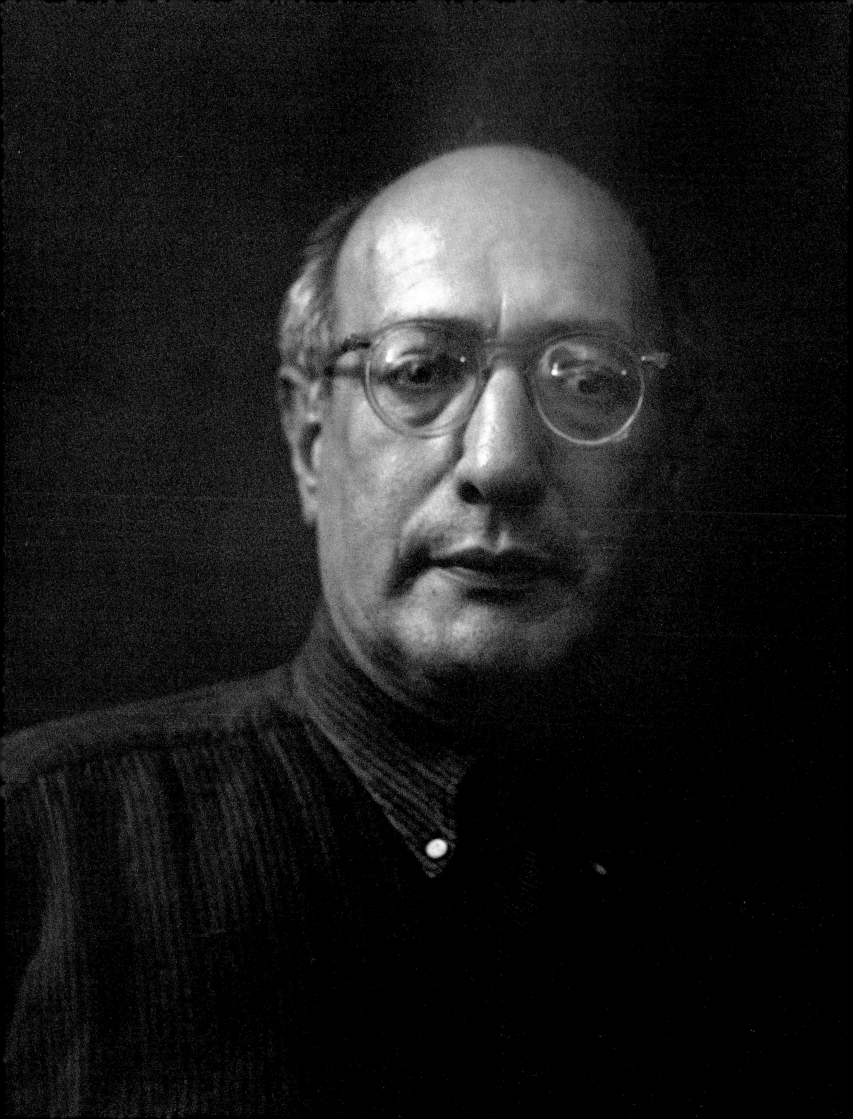

20

UNTITLED 1940

Watercolour on paper, 21 x 27½ in

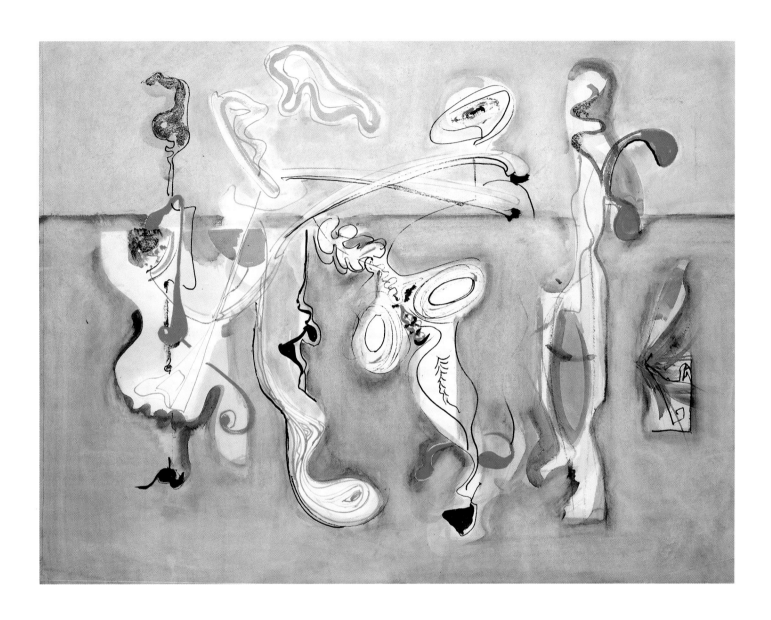

22

UNTITLED 1944

Oil on canvas, 38½ x 27½ in

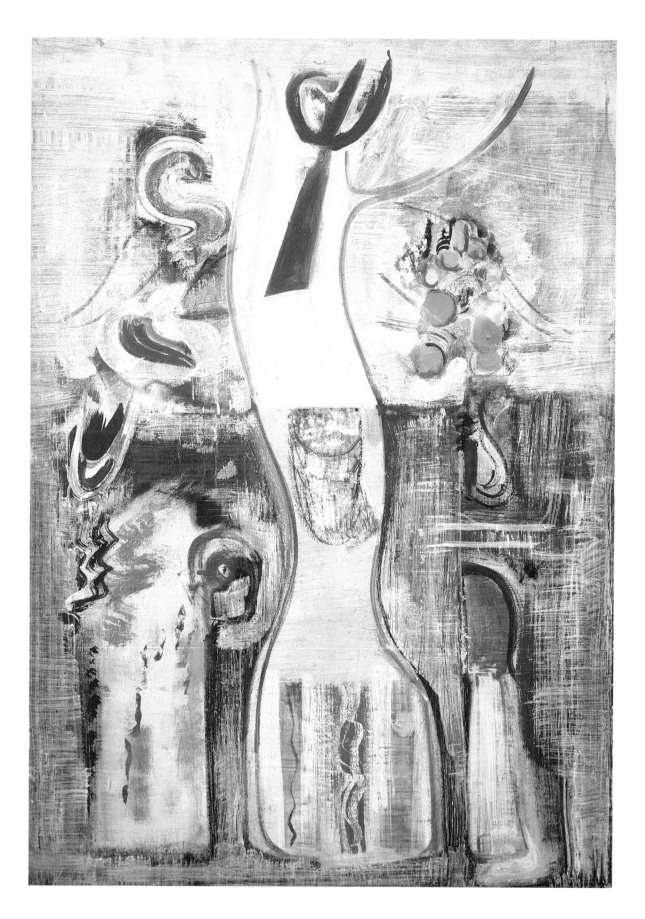

2 3

UNTITLED 1945

Oil on canvas, 37⅝ x 27½ in

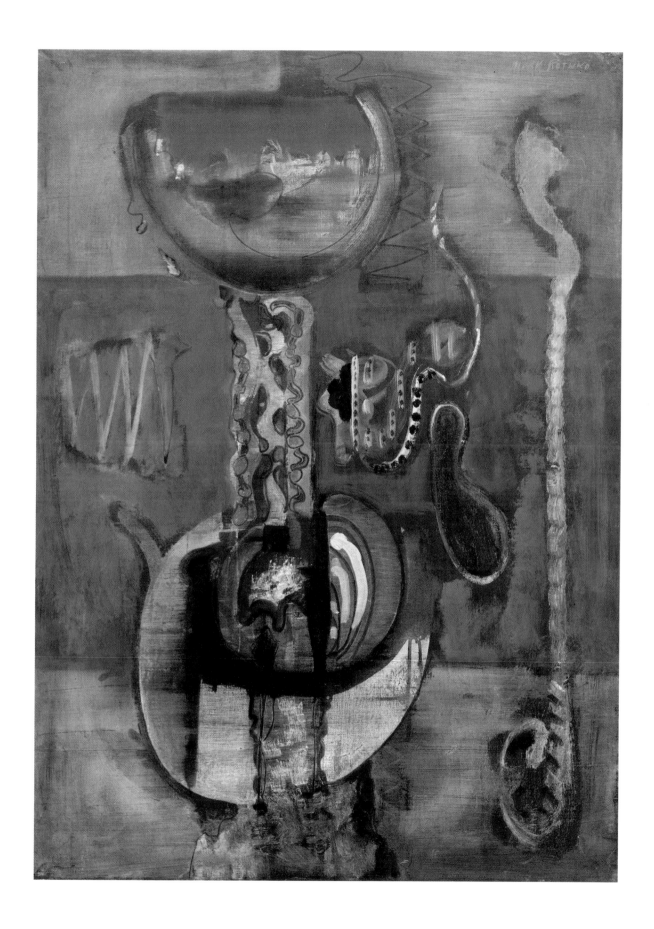

2 4

UNTITLED 1945-46

Oil on canvas, 39¼ x 27¼ in

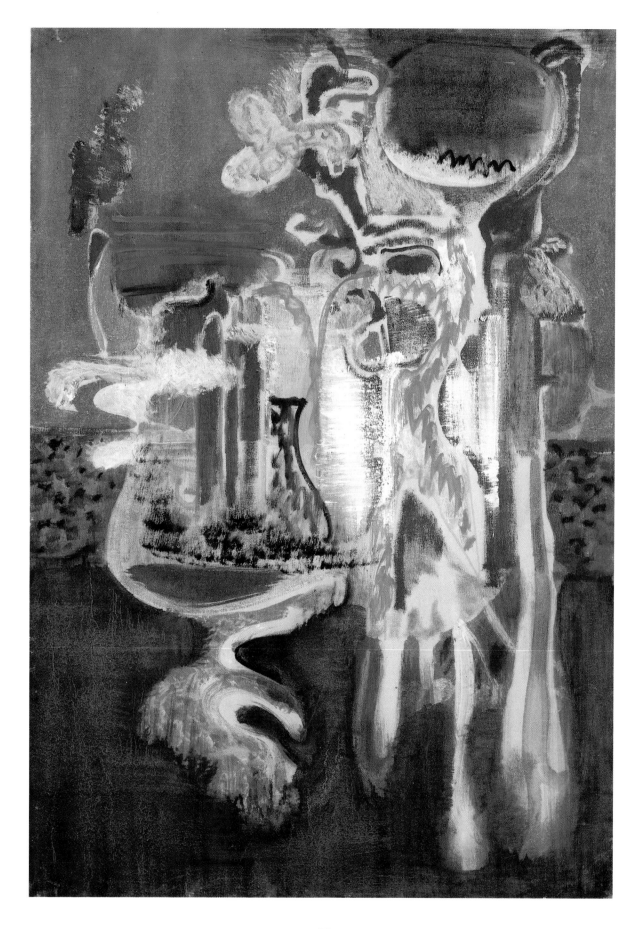

25

UNTITLED 1969

Acrylic on paper, 71 x 47 in

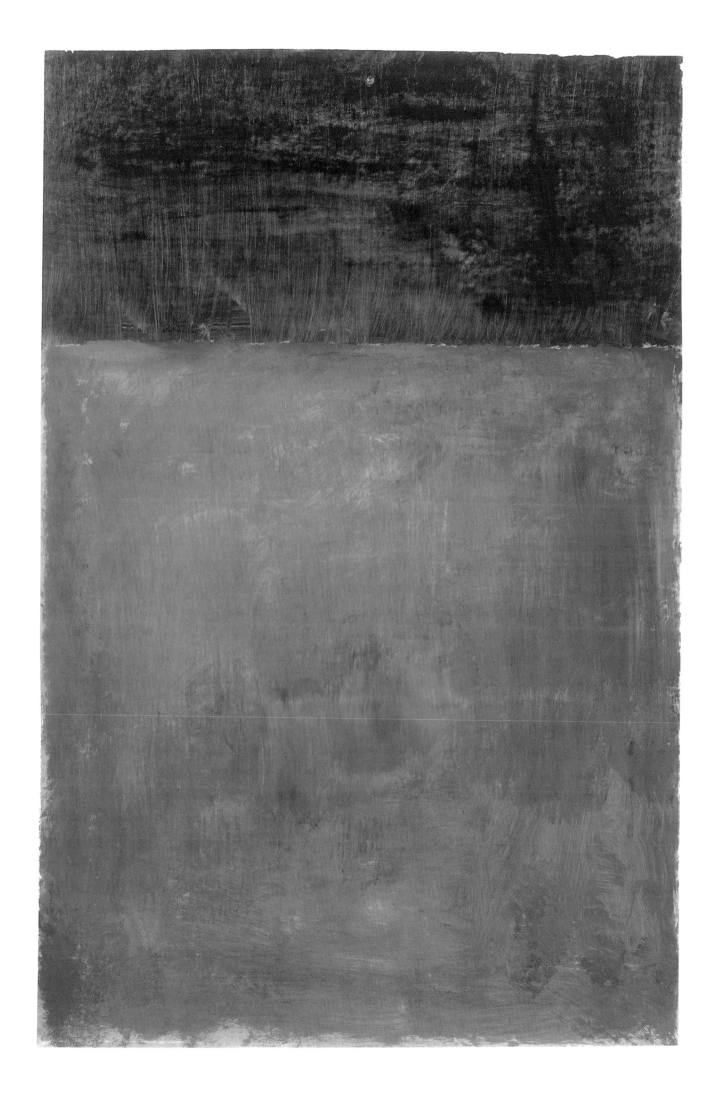

26

UNTITLED 1969

Acrylic on paper, 72 x 18⅛ in

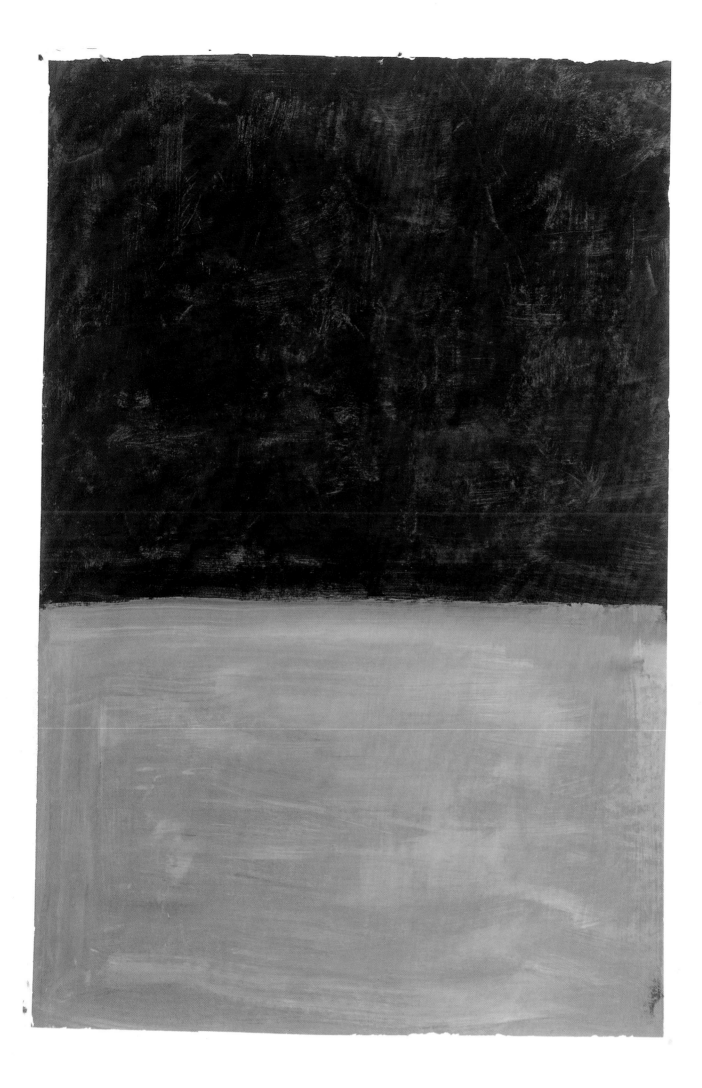

27

UNTITLED 1969

Acrylic on canvas, 68 x 60 in

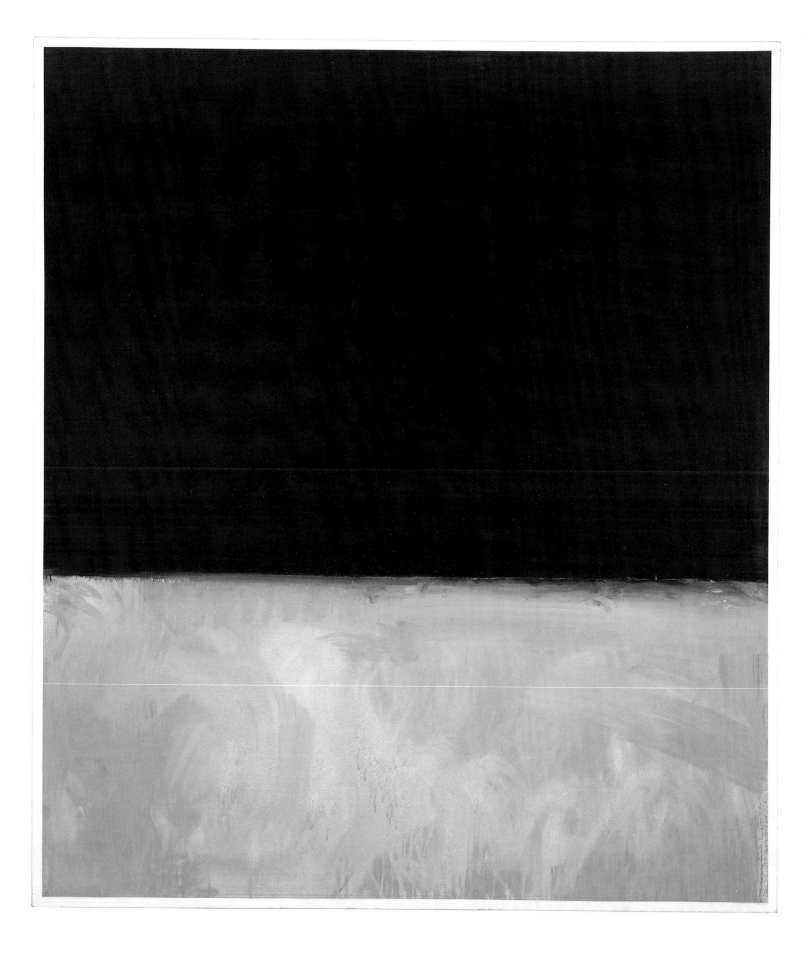

28

UNTITLED 1969

Acrylic on canvas, 81 x 93in

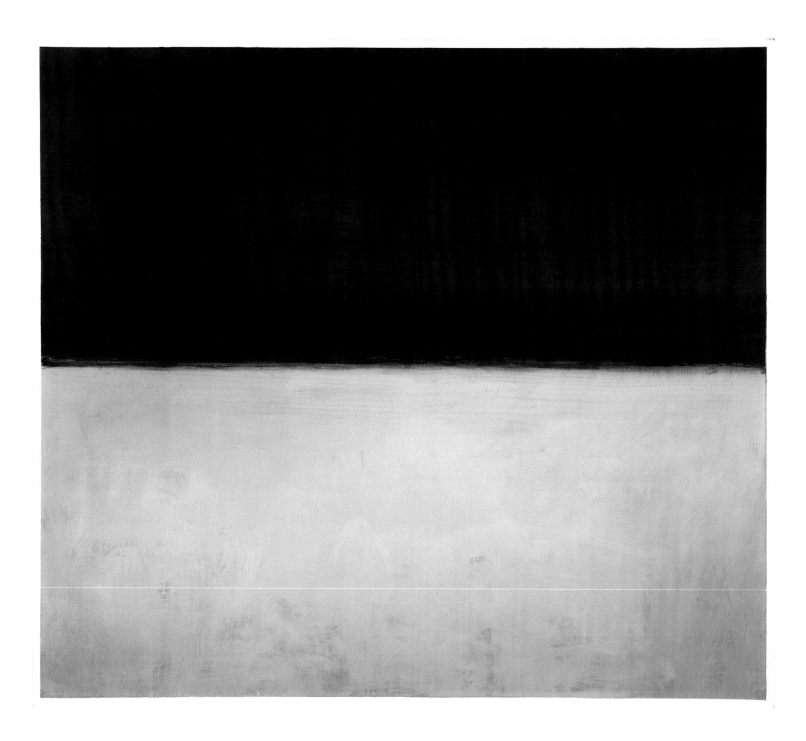

JOSEPH BEUYS

1

BRAUNKREUZ HOUSE
1962-64
[Vitrine]
Braunkreuz House: Wood, paper and wire
painted with braunkreuz;
Untitled: Archive box, with skulls and teeth of
mice and rats, charcoal rods and needle
Overall size: 81 x 86½ x 19½ in

2

SLEDGE WITH FILTER
1964-69
[Vitrine]
Filter: Cloth and fat;
Sledge: Sledge with fat, felt and torch
Overall size: 81 x 86½ x 19½ in

3

LOCH AWE
1963-70
[Vitrine]
Dust Box: Wooden box, dust, metal and
drawings on paper;
Loch Awe Piece: Lead box containing peat, wood
and copper Eurasian staff
Overall size: 81 x 86½ x 19½ in

4

DOUBLE OBJECTS
1974-79
[Vitrine]
Untitled: Battery cells; *Telephone:* metal
with string and braunkreuz; *Untitled:*
Syberian Symphony gramophone
records with bone; *Untitled:* Glass jars
with braunkreuz; *Untitled:* Enamel
bowls with soap; *Untitled:* X-ray plates with
metal clips and braunkreuz; *Irish Energies:*
Peat brickettes with butter and coal
Overall size: 81 x 86½ x 19½ in

5

BRAUNKREUZ
1962
Oil (braunkreuz)
2 parts: each 11¾ x 8¼ in

6

CONDENSED FIELD IN
BRAUNKREUZ
1963
Pencil and oil (braunkreuz) on magazine page
14¾ x 11 in

YVES KLEIN

7

BRAUNKREUZ

1963

Oil (braunkreuz) on newspaper

12 x 16½ in

Not reproduced

8

BRAUNKREUZ

1964

Oil (braunkreuz) and fat on card

Diameter: 8½ in

9 and 10

FOR BROWN ENVIRONMENT

1964

Oil (braunkreuz)

9: 2 parts, 31½ x 19½ and 31½ x 13 in

10: 2 parts, 23½ x 11¾ and 31½ x 13 in

11

BRAUNKREUZ

1966/67

Oil (braunkreuz) on magazine pages

2 parts: 11 x 15¾ and 12 x 16½ in

Not reproduced

12

ANTHROPOLOGIE DE
L'EPOQUE BLEUE (ANT 78)

1960

Blue pigment and synthetic resin on paper
mounted on canvas

85¾ x 52 in

13

CHEVEUX (ANT 46)

1961

Blue pigment and synthetic resin on paper
mounted on canvas

41½ x 29½ in

14

ARCHITECTURE
DE L'AIR (ANT 119)

1961

Blue pigment and synthetic resin on paper
mounted on canvas

103 x 78¾ in

15

ANTHROPOMETRIE (ANT 101)

1961

Blue pigment and synthetic resin, fire, gold
and cosmogony on paper mounted on canvas

165½ x 78¾ in

16
FIRE PAINTING (F 13)
1961
Fire on paper mounted on wood
25½ x 19¾ in

17
FIRE PAINTING (F 35)
1961
Fire on paper mounted on wood
31½ x 43½ in

18
FIRE PAINTING (F 45)
1961
Fire on paper mounted on wood
28½ x 40½ in

19
FIRE-COLOUR PAINTING
(FC 20)
1962
Fire and pigment on paper mounted on wood
43½ x 35 in

20
UNTITLED
1940
Watercolour on paper
21 x 27½ in

21
UNTITLED
1941
Watercolour on paper
20⅞ x 14⅞ in

Not reproduced

22
UNTITLED
1944
Oil on canvas
38½ x 27½ in

23
UNTITLED
1945
Oil on canvas
37⅝ x 27½ in

24
UNTITLED
1945-46
Oil on canvas
39¼ x 27¼ in

25
UNTITLED
1969
Acrylic on paper
71 x 47 in

26
UNTITLED
1969
Acrylic on paper
72 x 48⅛ in

27
UNTITLED
1969
Acrylic on canvas
68 x 60 in

28
UNTITLED
1969
Acrylic on canvas
81 x 93 in